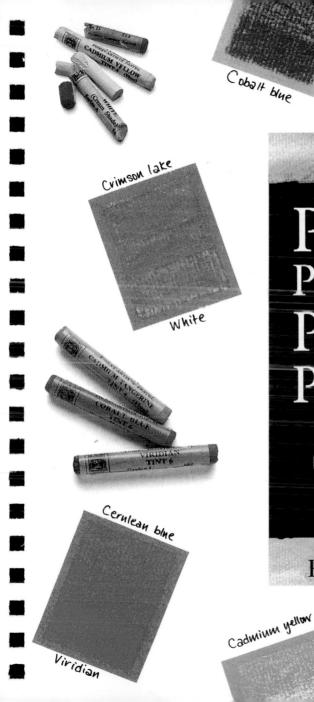

PASTEL PAINTER'S POCKET PALETTE

00420160

The

Practical visual advice on how to create over 600 pastel colours from a small basic range.

TINT 6

SEARCH PRESS

Rosalind Cuthbert

THE COLOURS

A QUARTO BOOK

Published in paperback in 2000 by Search Press Ltd Wellwood North Farm Road Tunbridge Wells Kent TN2 3DR

Reprinted 2006

Copyright © 1992 Quarto Publishing plc

ISBN-10: 1-84448-237-5 ISBN-13: 978-1-84448-237-5

All rights reserved. No part of this publication may be reproduced, transmitted or stored in any form or by any means, electronic or mechanical, without prior written permission from the publisher.

QUAR.PAS

Conceived, designed and produced by Quarto Publishing plc 6 Blundell Street London N7 9BH

Printed in China by SNP Leefung Printers

page **48** Viridian tint 6

Whilst every care has been taken with the printing of the colour charts, the publishers cannot guarantee total accuracy in every case. page 12 Lemon yellow tint 6

page 30 Crimson lake tint 4

page 54 White (cream shade) page 58 Cool gray tint 4

page 16

Cadmium yellow

tint 4

page 36

Purple

tint 4

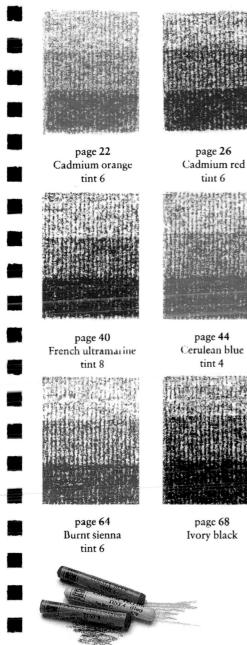

CONTENTS

USING THIS BOOK 4

OVERLAYING AND BLENDING COLOURS 6

ABOUT PASTELS 7

GREENS 8

SKIN TONES 10

USING **COMPLEMENTARIES 20** Oak in Winter

> THE COLOURS OF SNOW 34 Sun and Shadows

USING GREENS 52 Cypresses, Fiesole

USING MUTED COLOURS 62 Ronnie in the Air

EQUIVALENT COLOURS 72

Using This Book

UNLIKE PAINTS, which can be premixed on a palette, pastel colours have to be overlaid or blended together on the paper itself. The purpose of this book is to provide the pastel artist with an easy guide to nearly 600 colour overlays. In addition, the effects of four different coloured papers are shown for each one, thus creating over 2000 colour mixing effects. The experienced pastellist knows that a very large range of colours can be created by blending or overlaying pigments, but hopefully this book will suggest some new combinations, while for the beginner, it offers help in selecting a basic palette from

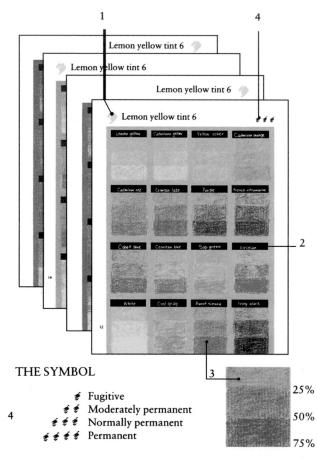

▲In pastel work, the colour of the paper plays an important part, so four different ones have been selected for the colour charts. Each set of four pages features one of 13 chosen colours, referred to as the "main" colour (1). For a visual guide to these, see pages 1 and 2. Each main colour is overlaid by 16 constant "basic palette" colours (2, and see opposite), which are repeated on every page. Every colour combination is shown in three different proportions of pigment to paper, approximately 25%, 50% and 75%, achieved by varying the pressure on the pastel stick (3). The symbol (4), appearing on the first page of each colour, denotes the degree of permanence of the main colour (some pigments are slightly more lightfast than others).

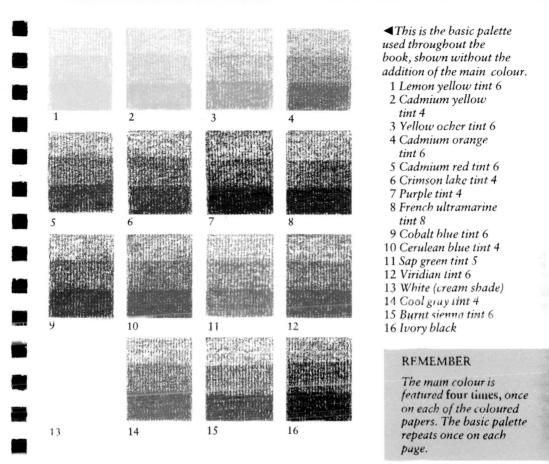

the many choices available. Soft pastels have been used throughout, and the paper used for the colour charts is Ingres, which is one of the most popular pastel papers.

THE BASIC PALETTE

Some pastellists work with a very large range of colours – though however many you have, there is always some shade in nature which does not correspond with a colour in your collection. The book seeks to show that even with a quite small range of colours, or basic palette, the permutations are enormous. Our basic palette of 16 colours is shown above, but this is only a suggested starting point. You may wish to substitute or include other colours. Only by experiment can you discover the palette that suits you best.

OVERLAYING AND BLENDING

LAYING ONE COLOUR on top of another creates a third colour, as shown on this page. Thus two primary colours, such as yellow and blue, or red and yellow, will make secondary colours — green and orange. The tertiary colours, browns and grays, which are a mixture of three primaries, are achieved by adding the third primary to the secondary colour. The ways in which overlays are achieved are many, depending on each artist's way of working. The examples shown on the opposite page provide some ideas.

CREATING SECONDARY AND TERTIARY COLOURS

Cadmium yellow and crimson lake overlaid to produce orange

Lemon yellow and cerulean blue produce a clear, bright green

Ultramarine and crimson lake produce purple

► The tertiary colour is shown where the three circles overlap

COMPLEMENTARY COLOUR OVERLAYS

▶ When two complementary colours, which are those opposite one another on the colour wheel, are "mixed", they create a range of neutral browns and grays.

Lemon yellow and purple

Cadmium red and viridian

Cobalt blue and cadmium orange

Crimson lake and sap green

Cerulean blue and cadmium orange

BLENDING COLOURS

► Colours blended with a torchon. This implement will mix colours very thoroughly, but it is only intended for small areas; if used too fiercely or over a large area it may scratch into the pastel.

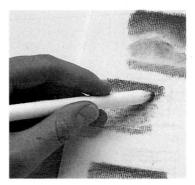

ABOUT PASTELS

Soft pastels are made from a single pigment or a blend of pigments bound with gum. Lighter tints are produced in the manufacturing process by adding whiteners, such as chalk and ching clay, and darker shades by udding black. Each make of pastel varies in the ingredients used, the range of colours and the number of tints or shades of each colour The numbering systems, which denote the colours and their tints and shades, also vary. Daler-Rowney, the brand used here, give each colour a name and number, e.g. Yellow ocher 663. The tint variations are numbered 0-8 (though no colour has as many as nine variations). The lower the number, the paler the tint.

▼ From left to right: Viridian and crimson lake blended with a torchon, a finger and cotton wool.

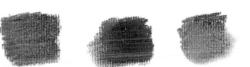

► A soft sable brush has been used to blend the colours here.

7

▼ Soft effects can be created by using a putty eraser to blend colours. Use it lightly, taking care not to remove the top layer of colour.

GREENS

GREENS ARE ONE of the trickiest of colours to mix, because nature provides such a large variety — greens range from near-blacks and deep, rich olives through subtle blue-greens to brilliant, acid, almost yellow greens. If your main interest is landscape you may in time have to add a few more pastel colours to your range, but these pages show some of the many variations you can achieve with the basic palette. Notice that if you mix two slightly "cool" colours such as lemon yellow and cerulean blue, the green will be clear and sparkling, while two "warmer" colours such as cadmium yellow and ultramarine, which have a slight bias towards red, will give a denser, duller colour. Don't forget that your choice of coloured or tinted paper will also affect the result.

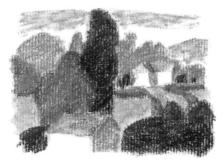

◄ Picture made using the mixes opposite for all the greens.

Ivory black Lemon yellow

8

Purple Yellow ocher

Ivory black Cadmium yellow

Cadmium orange Cerulean Lemon yellow

Purple Lemon yellow

Cadmium red Cerulean Lemon yellow

◀Other ways to make greens and greenish shades. Don't forget that it makes a great difference what order the colours go down in. Generally, darker colours first, yellows on top unless a very dark shade is required.

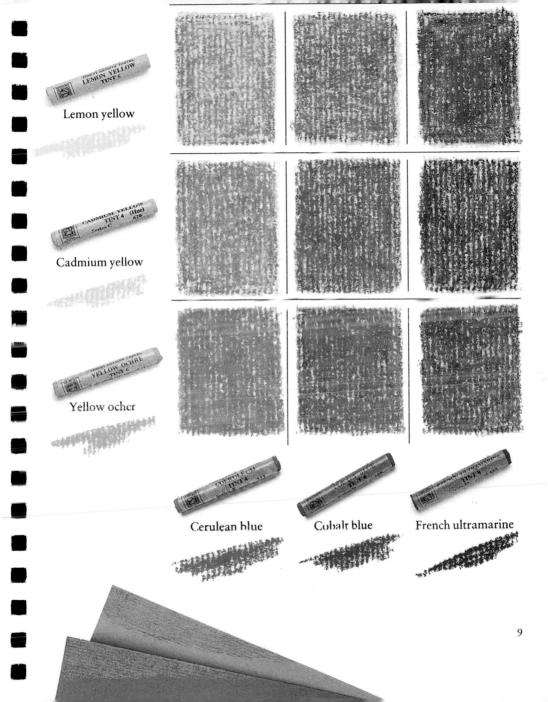

SKIN TONES

WE TEND TO THINK of skin as basically pink, cream or brown, but in fact skin tones vary enormously even within the same ethnic group. The lighting conditions also make a great difference; for instance, in shadowy areas, pale skins can look bluish, greenish or mauve, while dark skins could seem greenish brown or purple-black. Pitching the tonal value correctly is at least as important as finding the "right" colour. And you may find yourself using quite surprising colours to indicate certain nuances of light or shade.

Much can be done with a very few colours – in fact it is best to keep your palette simple, especially at first.

► This portrait was drawn with charcoal on cool grav paper and then coloured with yellow ocher, crimson lake. purple and white. Cerulean was the main eve colour, but was softened with white and purple. White was used delicately but extensively, with gentle finger blending to achieve softer passages. Shadowed areas were done with the same colours, but with more purple and less ocher and white

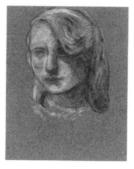

Main blend for lit area white over a small amount of crimson lake over yellow ocher

Main blend for shadow area white over crimson lake over purple

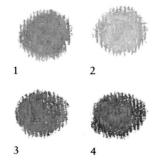

10

Variations also used 1 White over crimson lake over yellow ocher 2 White over 3 White over yellow ochre over yellow ochre over purple 4 White over crimson lake over purple There are many different formulas for painting flesh - artists invent their own palettes based on observation, personal preference and style - so take these charts as a guide only.

A Very dark

complexions 1 Burnt sienna over ultramarine 2 Orange over black 3 Burnt sienna over black

Shadows 4 Burnt sienna over

- ultramarine over black
- 5 Viridian over cadmium red over black

Highlights 6 White over cadmium orange over

purple 7 White over cerulean over burnt sienna

C Olive complexions 1 Gray over

- cadinium yellow over burnt sienna
- 2 White over orange over purple
- 3 White over orange over cerulean

Shadows

- 4 Cobalt blue over cadmium red over yellow ocher
- 5 Orange over purple

Highlights 6 White over

vellow ocher

7 White over yellow ocher over cerulean

A	2		3
4	5	6	7
В			
В			
1	2		3
4	5	6	7
C			
1	2		3
4	5	6	7
D			
1	2		3
4	5	6	7

- B Mid-brown complexions
- 1 Yellow ocher over burnt sienna
- 2 Orange over burnt sienna
- 3 Gray over burnt sienna
- Shadows
- 4 Burnt sienna over cobalt blue
- 5 Orange over ultramarine
- Highlights:
- 6 White over cerulean over yellow ocher
- 7 White over cerulean over crimson lake
- D Pale complexions 1 White over yellow
- ocher 2 White over
- crimson lake over cadmium yellow
- 3 White over orange over cerulean
- Shadows
- 4 White over crimson lake over cerulean
- 5 White over cadmium yellow over purple
- Highlights
- 6 White over cerulean
- 7 White over cadmium yellow

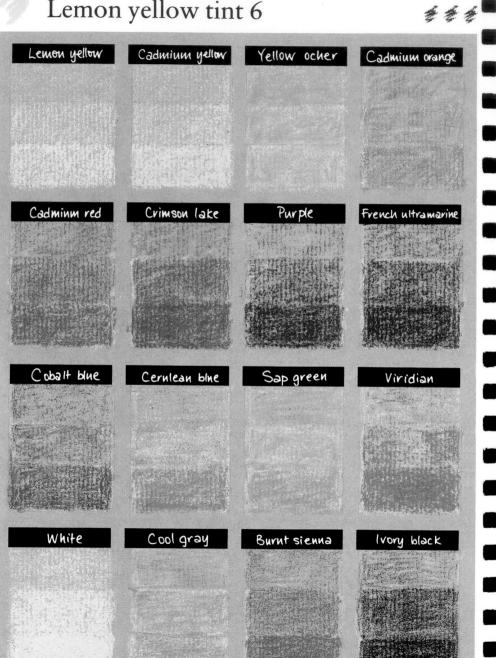

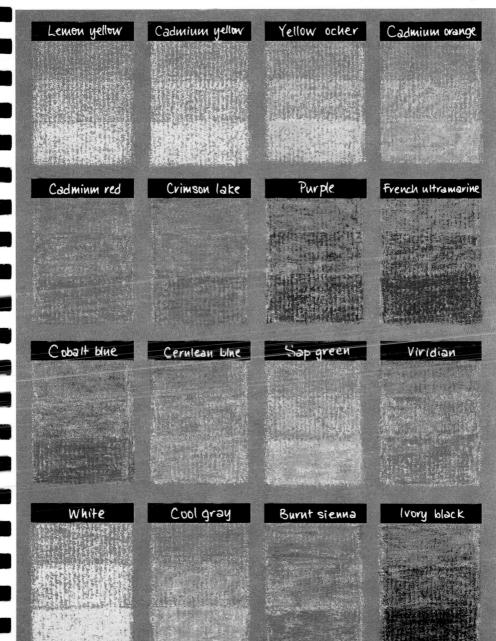

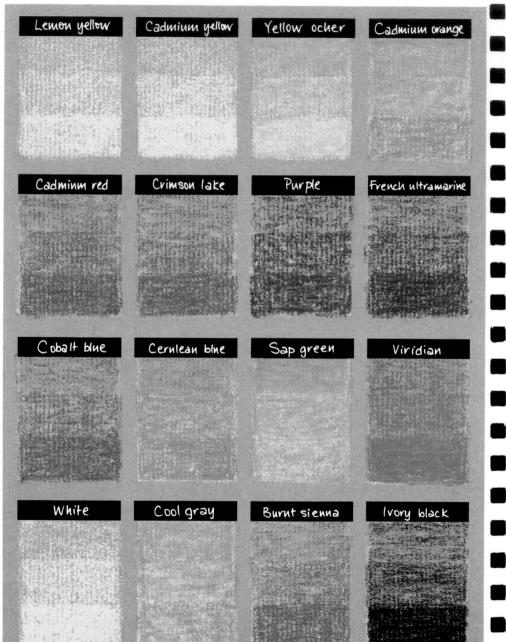

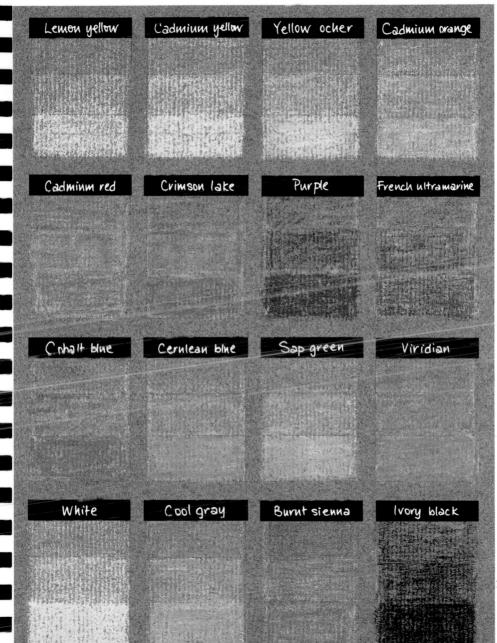

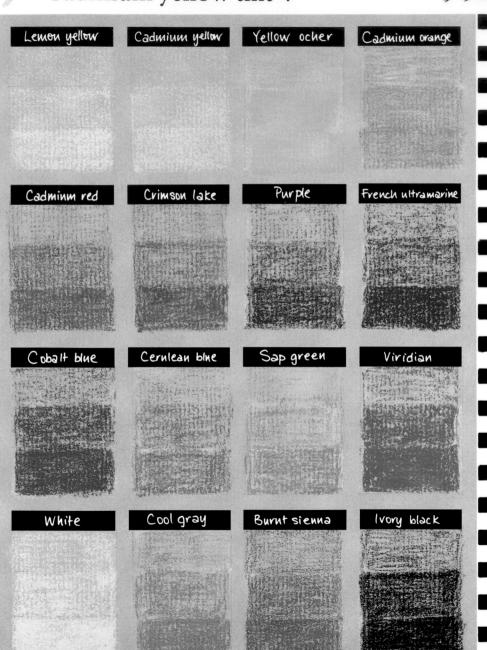

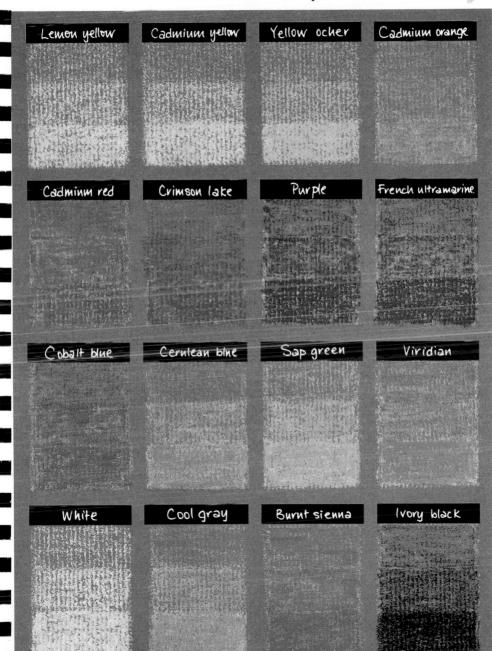

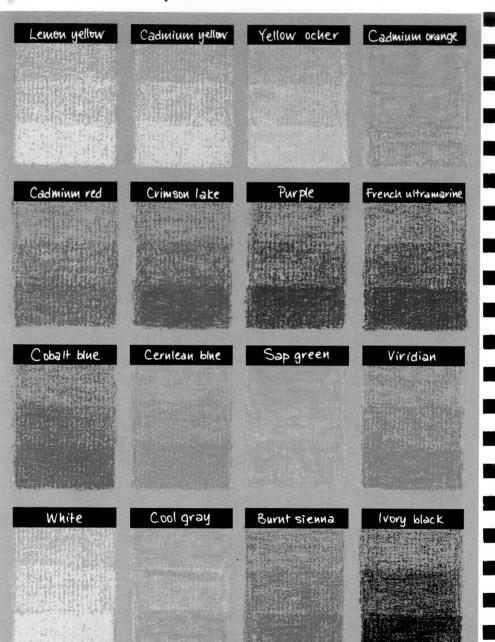

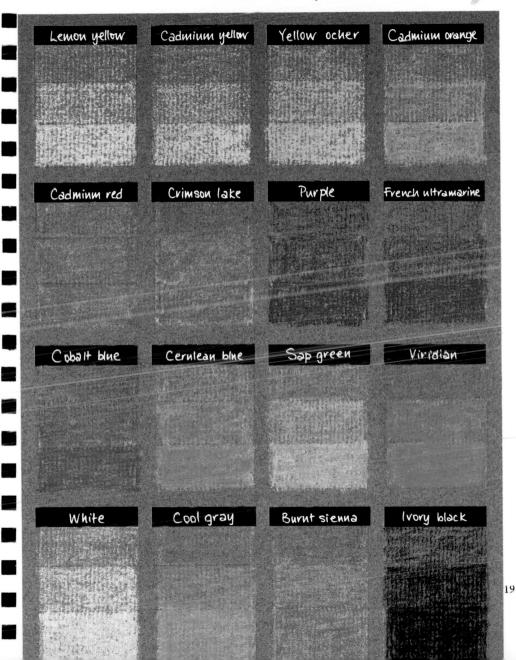

USING COMPLEMENTARIES

Sally Stride – Oak in Winter

IN THIS SCENE the slanting winter light is conveyed by use of warm and cool violets and warm yellows, punctuated by vivid pinks and browns. Very speedily drawn on white paper, the colours are smeared or smudged into one another with fingers and then drawn over again so that the colours have a quality of being vigorously shaken or stirred together.

▲ The far hill is drawn first in red violet and crimson lake, then softened to a haze with fingers and a liberal coating of pale violet. Either side are patches of pale and bright cadmium yellow rubbed into underlying pale mauves.

► The active, almost frenzied marks of the pastel sticks give light and energy to the pale gold foreground. Trees are backlit, in greenish brown and black, and colour spills over the paper as light over the landscape. The oak tree is drawn in brown, black and crimson, seemingly dissolving as colour is dragged into surrounding areas by the movement of the pastel.

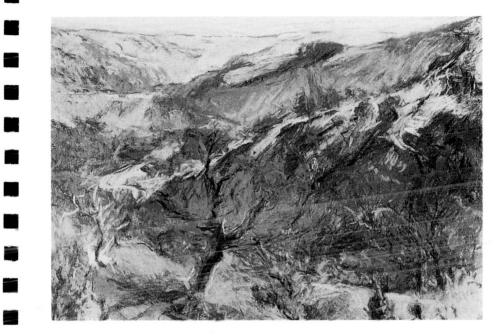

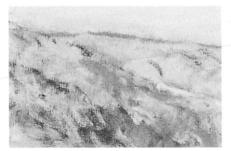

-

The light treatment of the sky shows clearly how the artist puts down one colour, rubs it lightly to soften it, and then overlays it with a second, third or fourth colour.

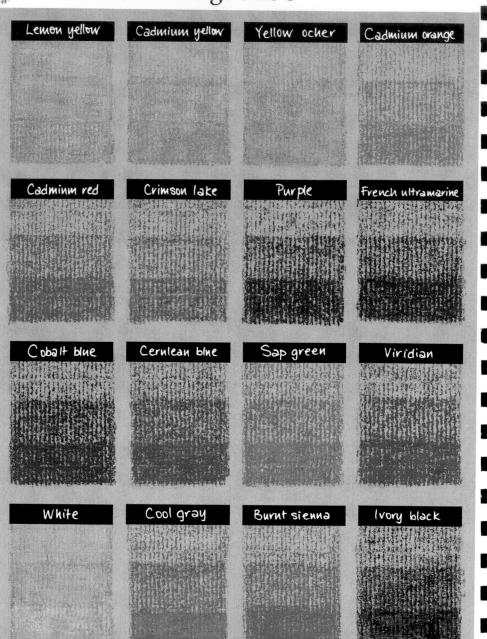

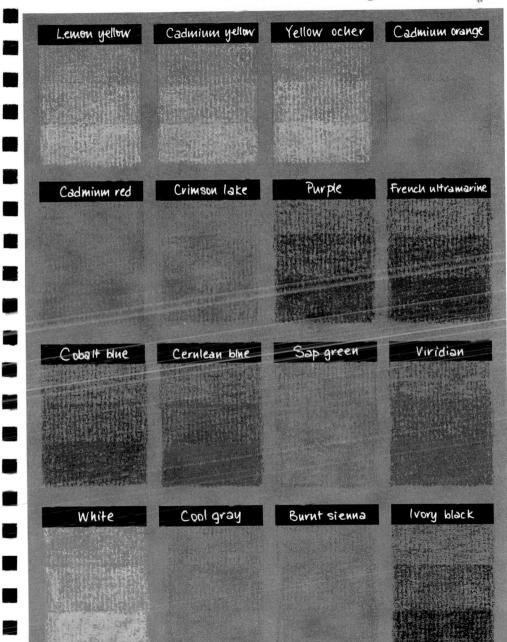

23

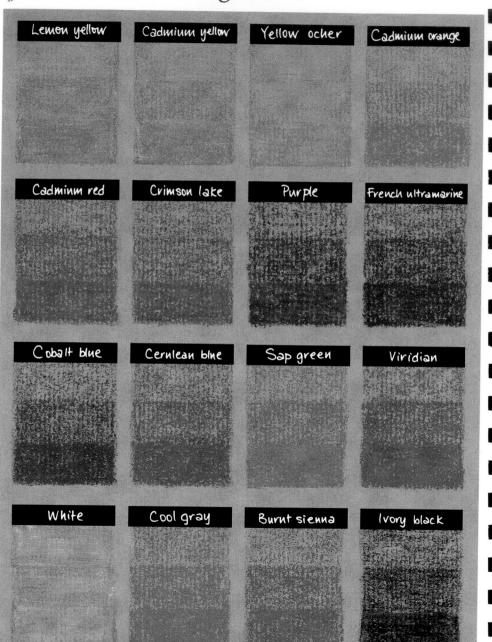

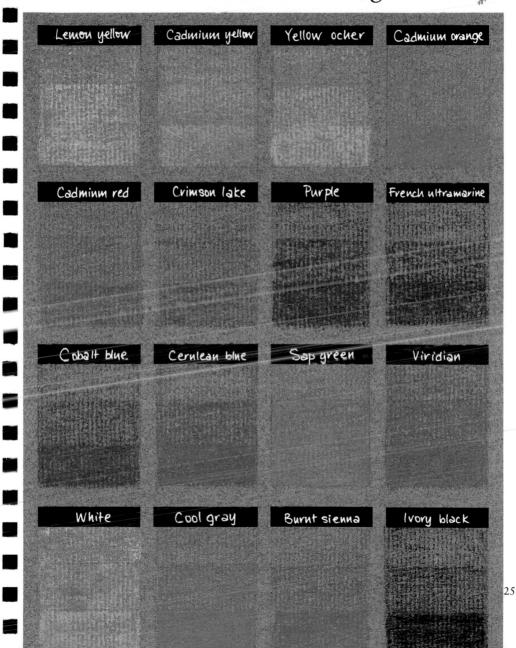

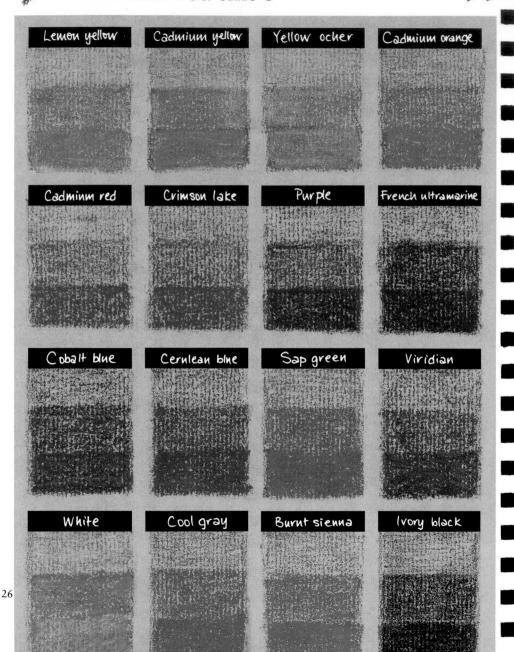

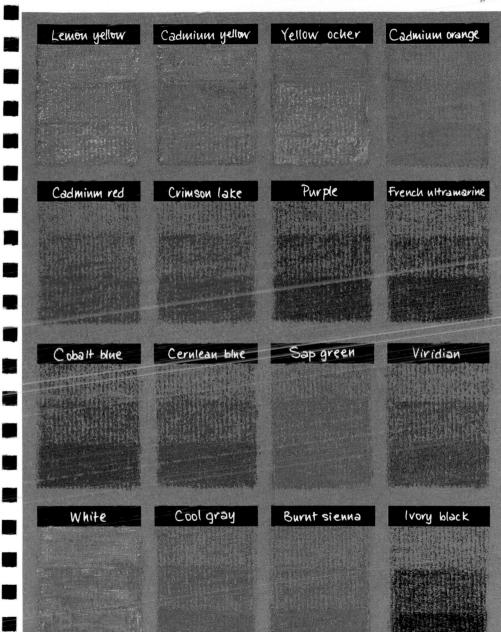

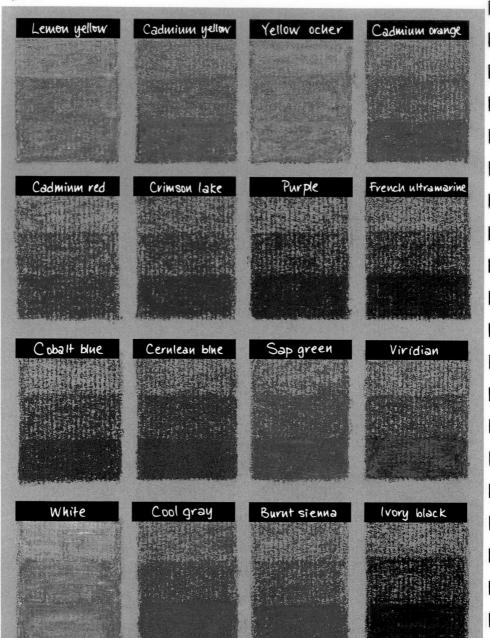

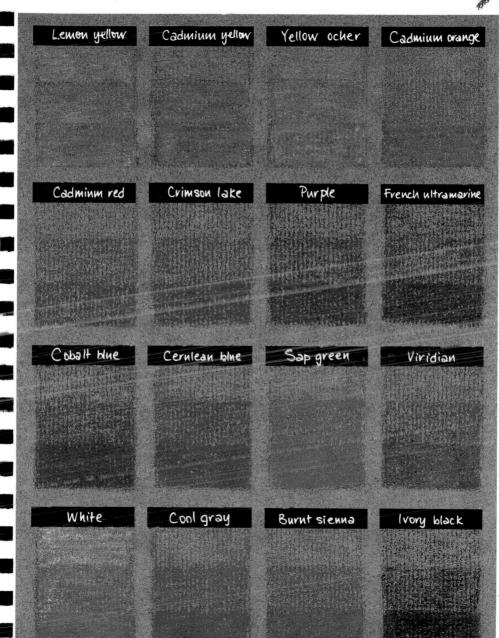

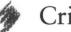

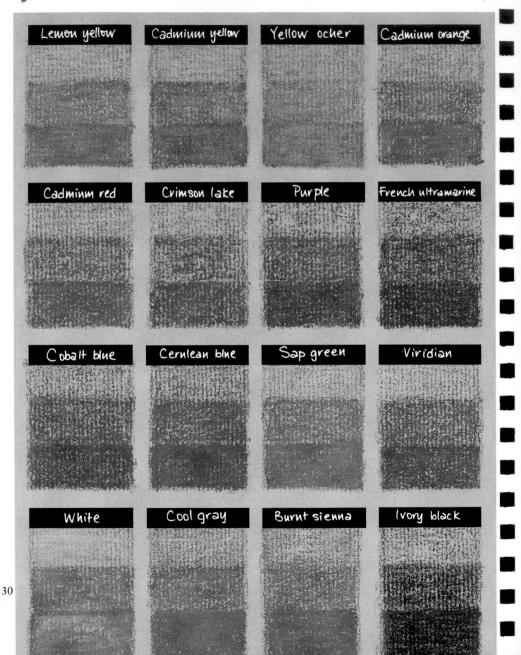

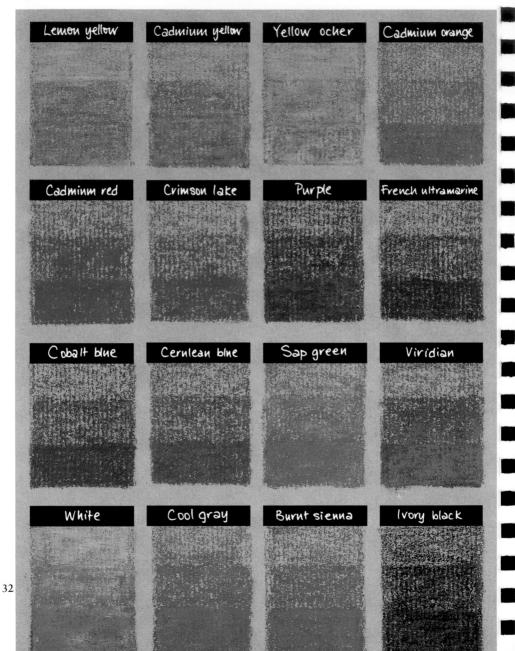

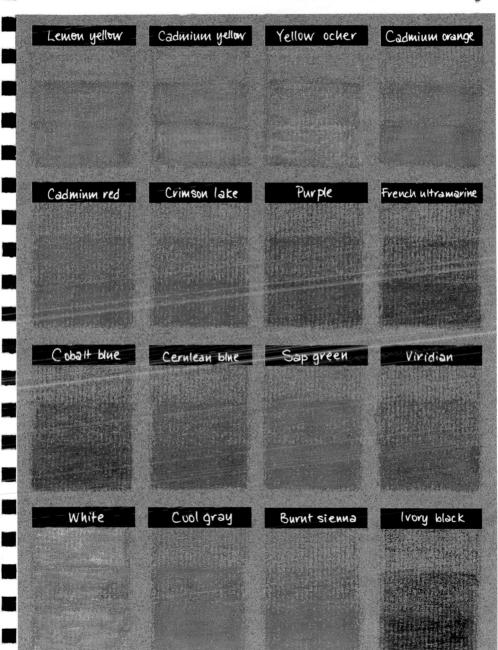

The Colours of Snow

Margaret Glass – Sun and Shadows

THE RICH TERRACOTTA PAPER used here provides a lively contrast to the otherwise cold palette. Its enlivening and colour-enhancing effect is particularly noticeable in the cold snow shadows. The weak warmth of the sun and its reflection in the snow are suggested with pale cadmium yellow and touches of lemon yellow — no white is used. The picture is given unity by the way the snow colours are repeated more gently in the sky.

Dark cerulean is the main colour for the snow shadows, highlit with blue-green and violet with sepia touches. For the sunlight, pale cadmium is accented with pale blue-green and pale violet.

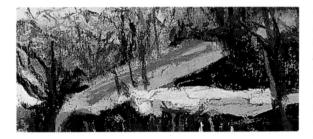

▶ Pale, cold cerulean, very pale violet and cadmium yellow are blended together to create the soft tints in the sky, over which tree branches have been gently and deftly drawn using gray-blue and graybrown. Stronger tones or colours would have been too harsh.

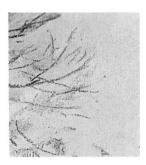

The thick wedges of snow on the sheds are mostly in the shade, so gray-violet and dark cobalt blue are used, but one patch is struck by sun, and here a thick, heavy stroke of pale cadmium is applied. Above, the distant trees are greenish gray and neutral gray over pale cerulean, much more gently drawn where the growth is delicate.

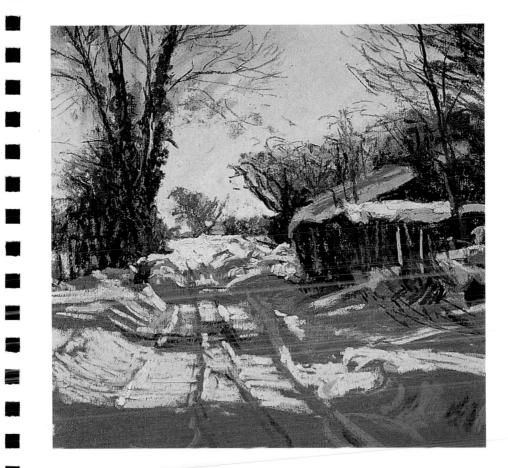

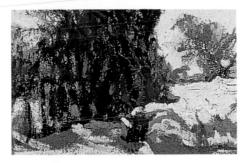

The hedgerow has been drawn in with redbrown, blue-gray, and sepia and black, while the snow clinging to the branches is depicted in cerulean. The red-brown paper plays an important role in suggesting light on trees behind the hedge.

36

Purple tint 4

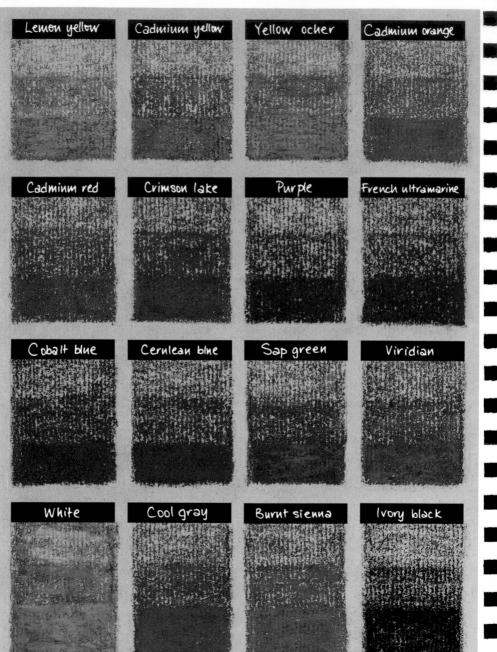

* *

Purple tint 4

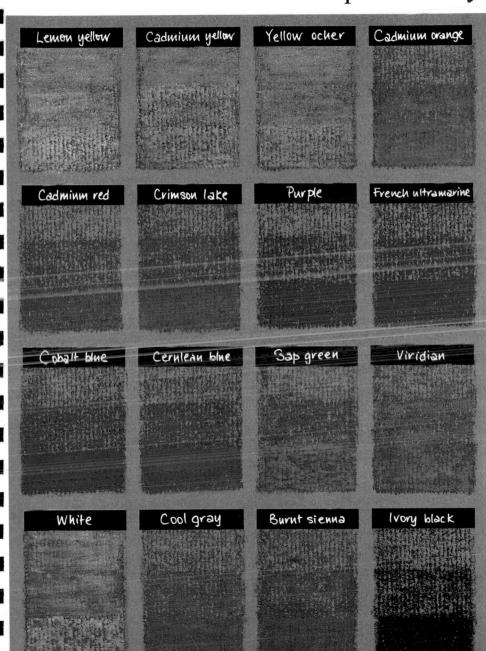

Purple tint 4

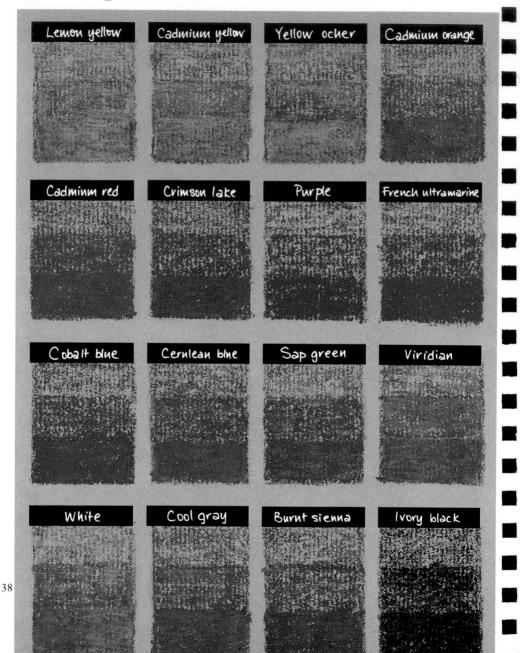

Purple tint 4

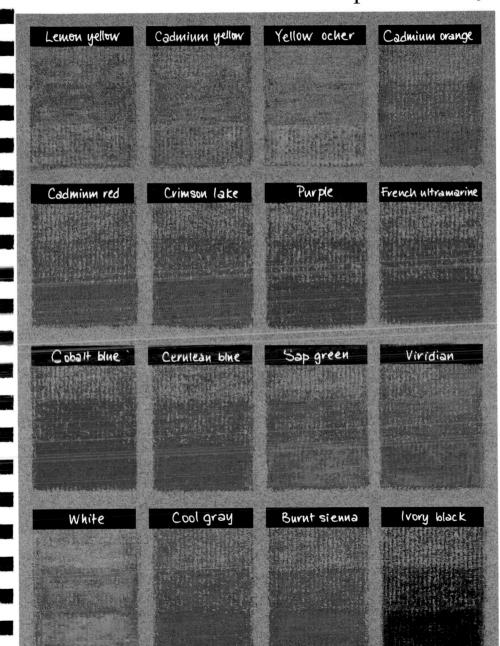

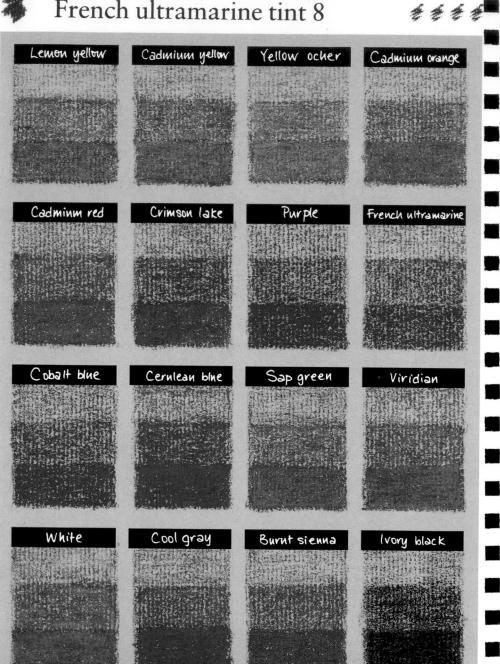

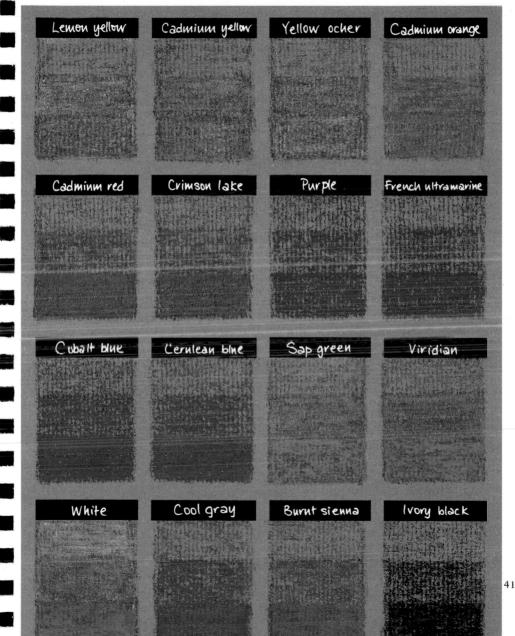

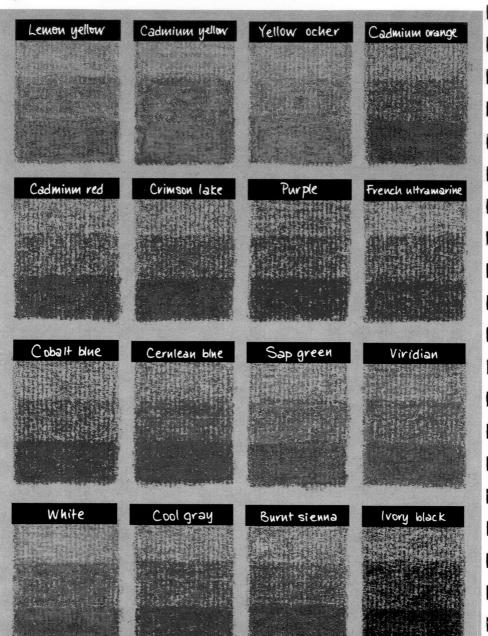

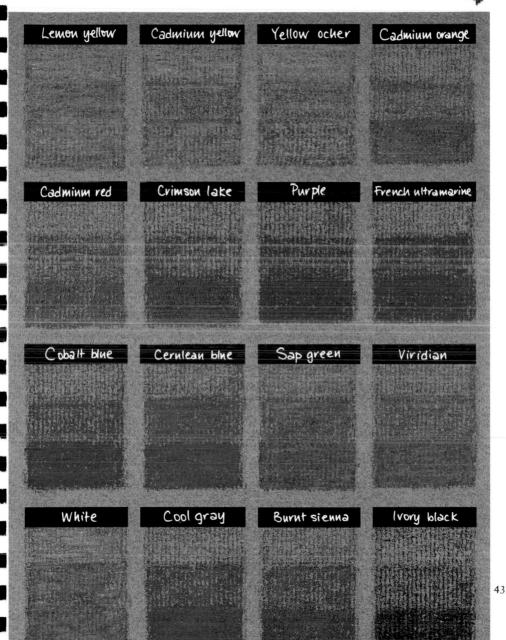

44

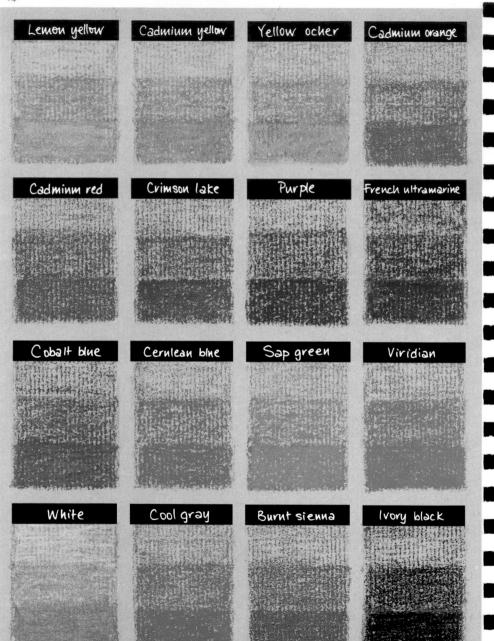

* * 1

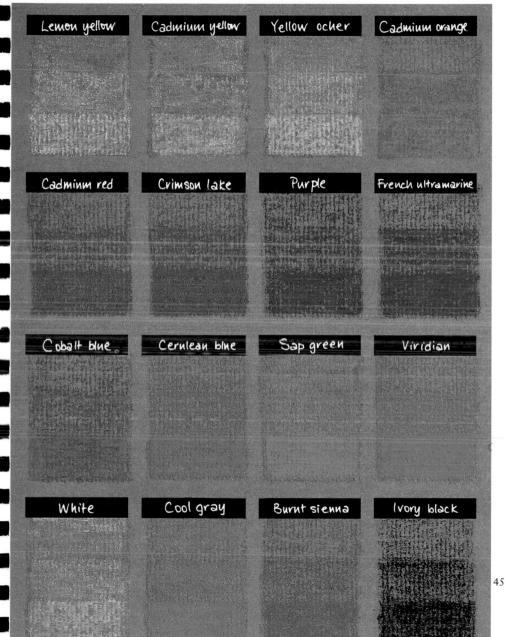

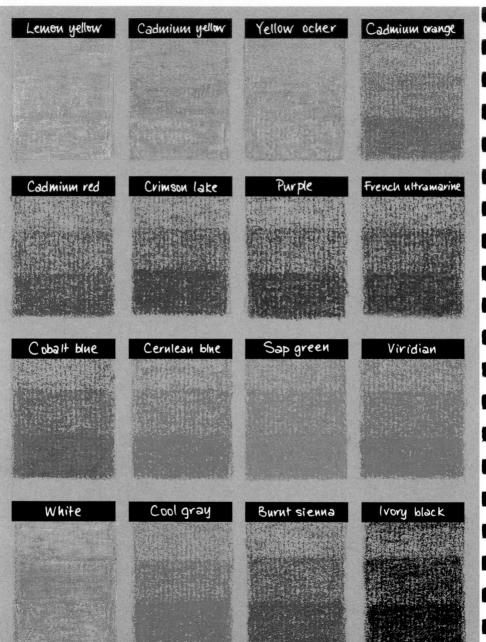

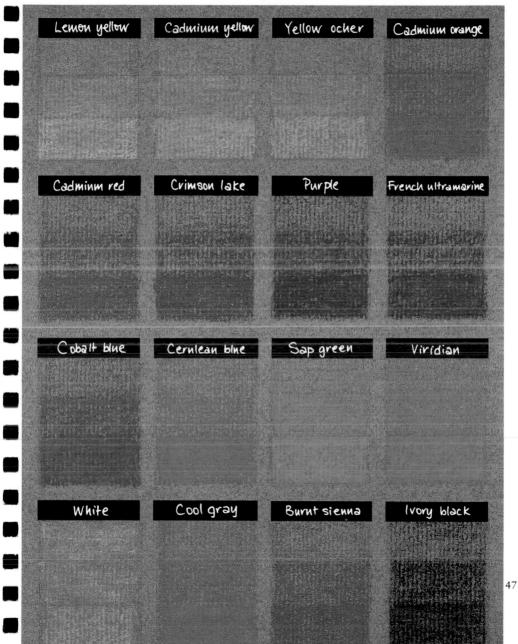

Viridian tint 6

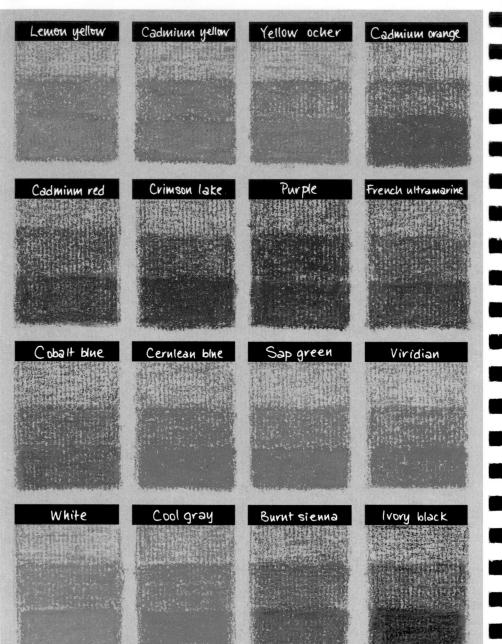

Viridian tint 6

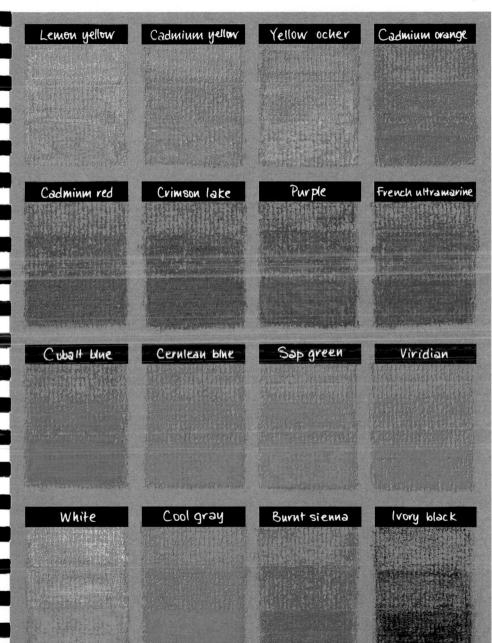

Viridian tint 6

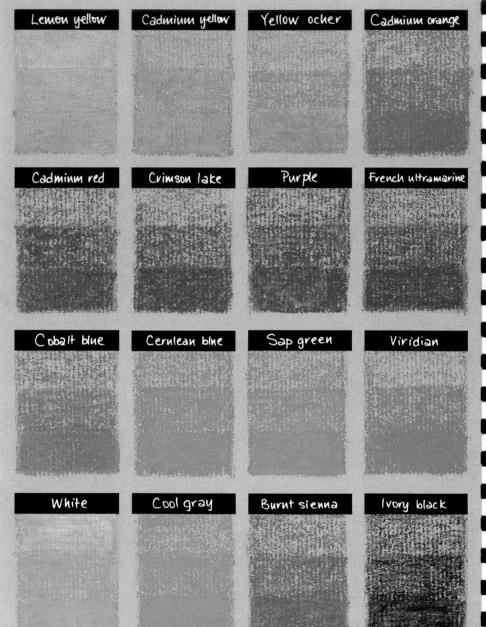

Viridian tint 6

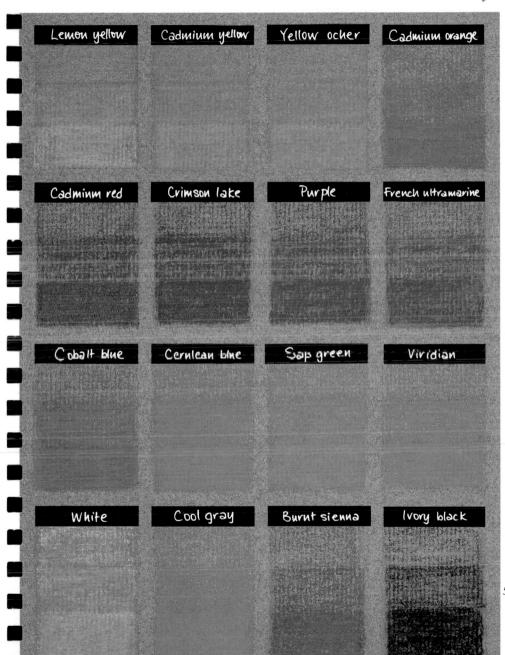

USING GREENS

Rosalind Cuthbert – Cypresses, Fiesole $21^{1/2} \times 29^{1/2}$ ins

IN THIS STRONGLY LINEAR DRAWING viridian has been used as a base, with other greens laid on top. In many areas these have been overlaid with darker, cooler or brighter colours to increase tonal contrasts and thus heighten the dramatic atmosphere. The paper is a greenish brown, sufficiently neutral to appear pinkish through the greens and greenish through the pinks of earth and shadows. This imbues the applied colours with a gentle liveliness.

▼ The trees on the left were drawn using the same greens — permanent green and Hooker's green – overlaid with ultramarine blue and deep turquoise, pale cream and pink. Trunks and branches are combinations of permanent rose and pale chrome green, providing a pale, warm contrast to the dark, cool masses of the foliage.

► The pale English red ground is lightly dragged across the paper, allowing greenish paper to break through. Tree shadows of crimson, burnt sienna and ultramarine provide warm horizontal counterpoints for the main verticals of the composition. ■ The main colour used in this part of the picture is viridian. The shadowed side of the tree has overlays of ultramarine and black, while the sunlit side is lightened with pale chrome green and lemon yellow. An outline of madder lake provides a lively edge which separates one dark tree from the next as well as suggesting the heat of the day.

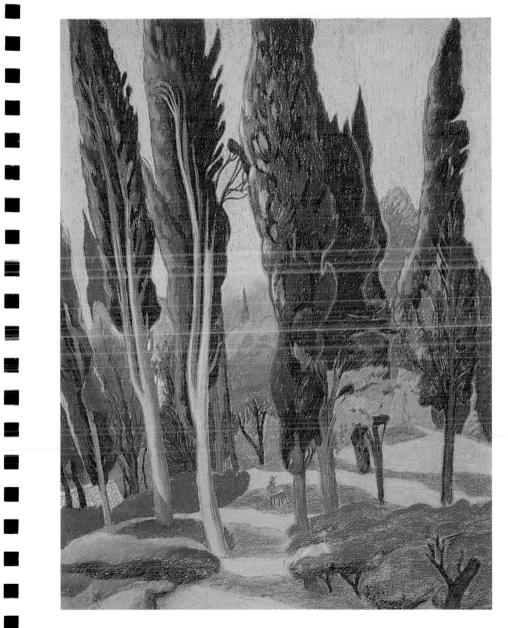

- 1

White (cream shade)

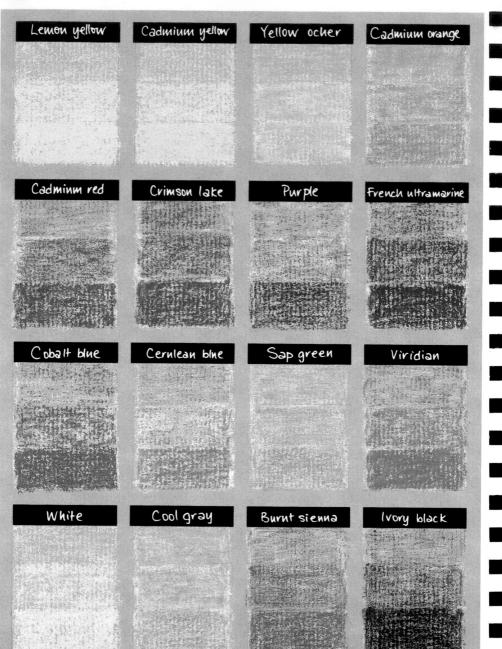

White (cream shade)

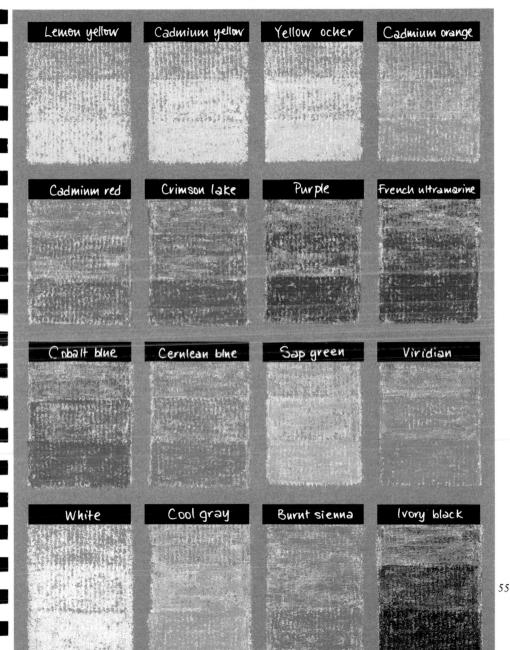

White (cream shade)

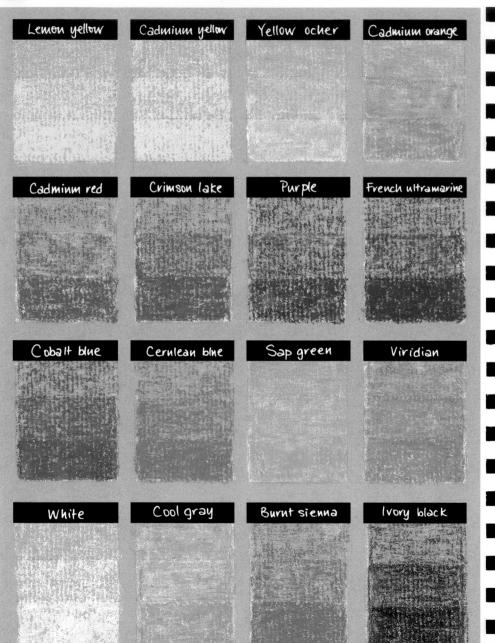

White (cream shade)

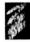

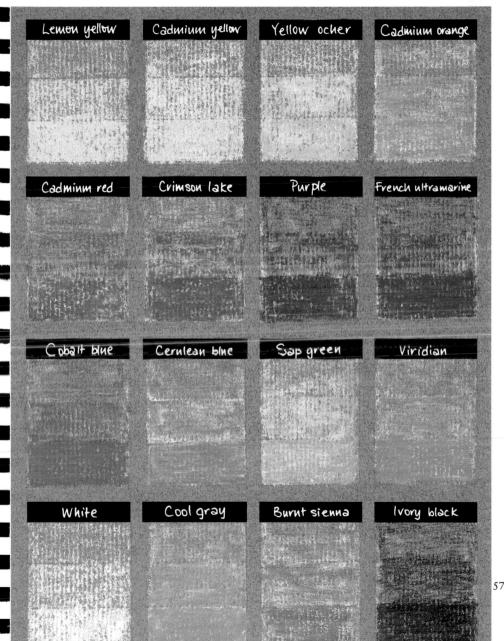

Cool gray tint 4

58

Cool gray tint 4

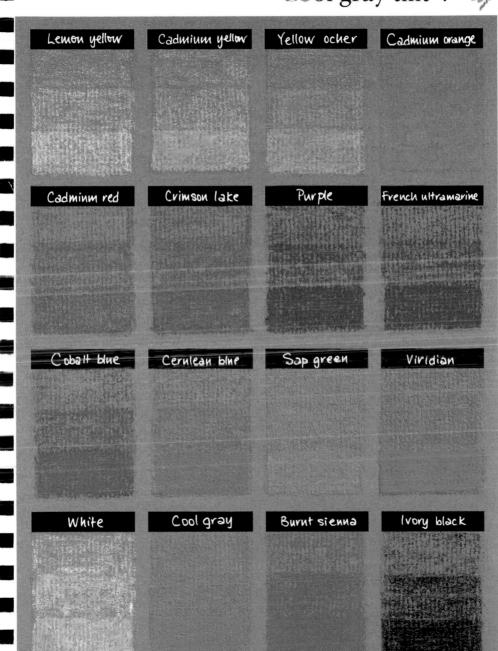

Cool gray tint 4

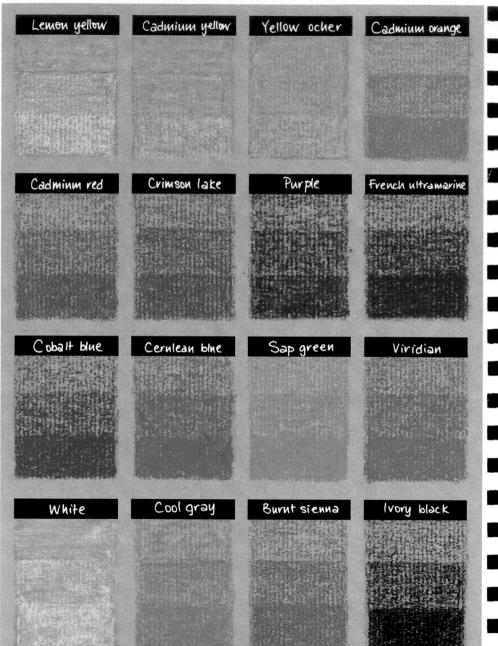

Cool gray tint 4

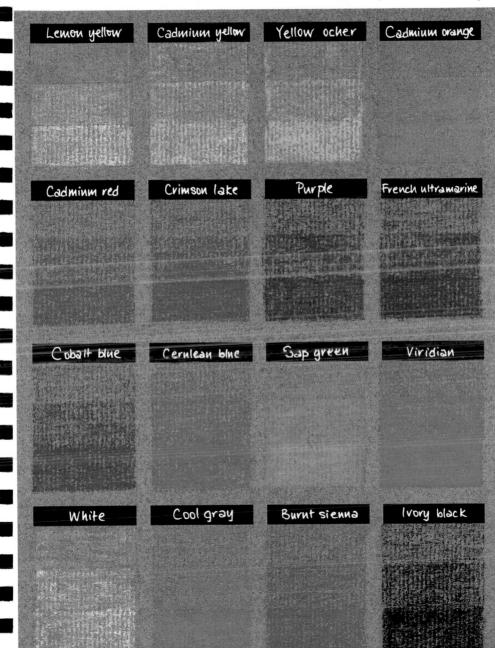

USING MUTED COLOURS

Carole Katchen – Ronnie in the Air $27\frac{1}{2} \times 39$ ins

THE PASTEL has been done on a cool gray paper, with the colours broadly hatched on and then lightly finger-blended. The whole surface is treated in this way, with white highlights added afterwards. The effect is light and energetic, in keeping with the subject. The palette is very simple — consisting mainly of gray,ocher, white and umber — but other colours have been smudged in too, further enlivening the surface.

▼ Pink and mauve create soft shadows, warming up an otherwise cool colour scheme.

62 Umber, burnt sienna and gray are used to describe the bronze skin against the light.

▲ Empty areas of the composition effectively heighten the effect of movement by contrast. However, nowhere is the colour completely flat; ocher and pale pink hatched together suggest gently vibrating light and air.

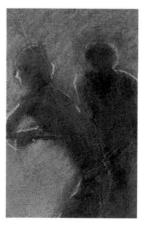

▲Vigorous fingerblending softens the forms to suggest distance.

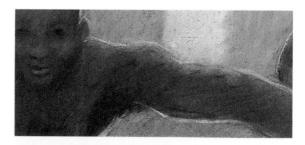

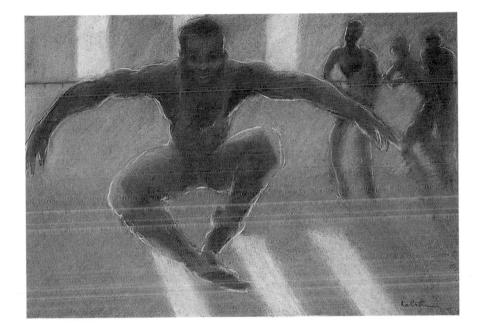

◀ Ultramarine, Prussian blue and crimson partly smudged together form the dancer's leotard. The white outline suggests speed as well as emphasizing the backlighting.

Burnt sienna tint 6

64

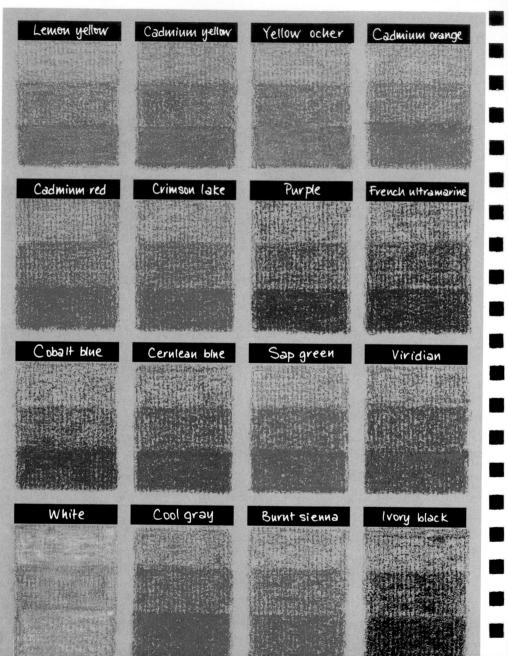

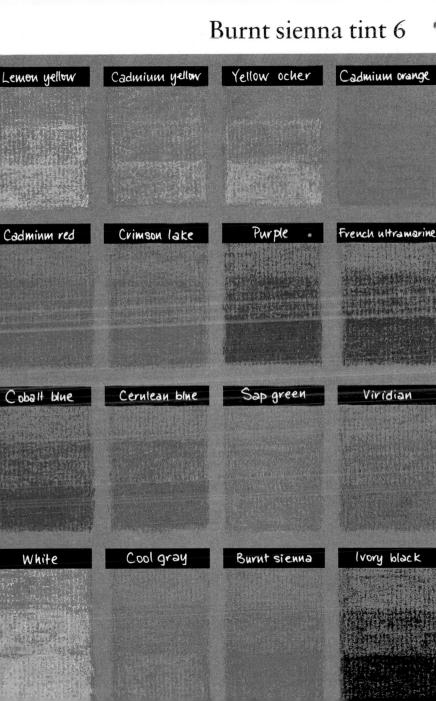

Burnt sienna tint 6

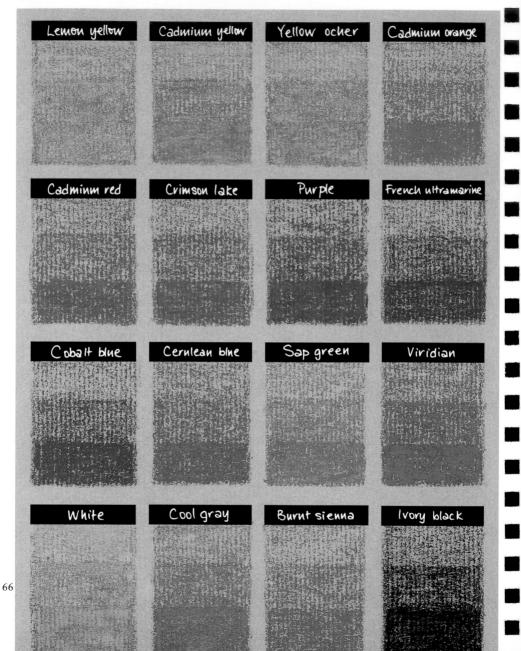

Burnt sienna tint 6

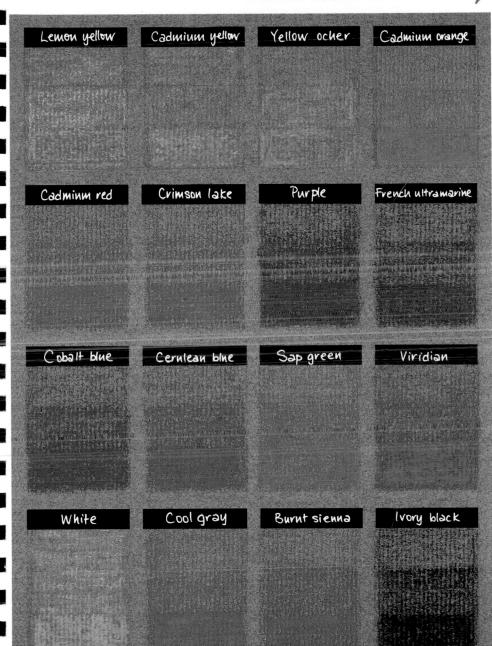

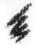

Ivory black

Ivory black

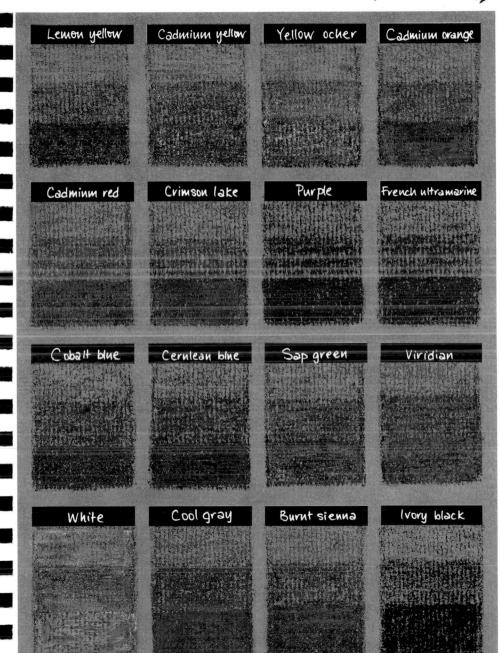

Ivory black

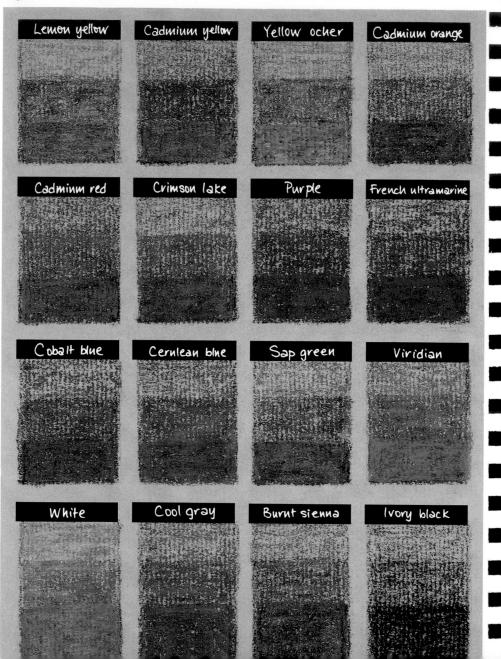

Ivory black

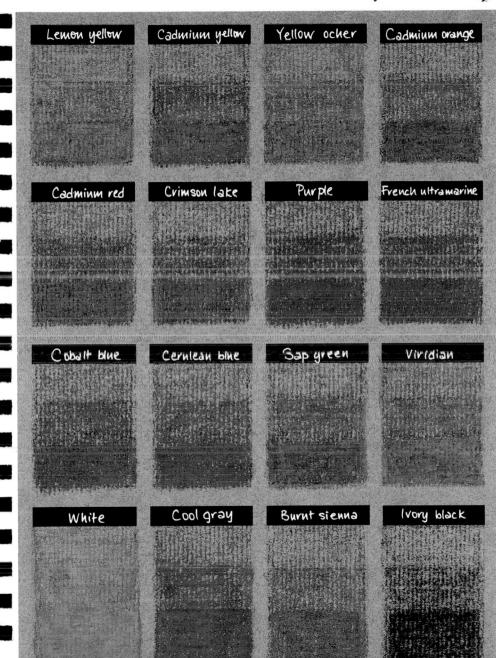

EQUIVALENT COLOURS

	ROWNEY	REMBRANDT	SCHMINCKE	SENNELIER
	Lemon yellow tint 6	Lemon yellow 205,5	1 lemon Sunproof yellow D	Lemon yellow
A	Cadmium yellow tint 4	Light yellow 210,5	Sunproof yellow 2 light H	Cadmium yellow light 300
All and a second	Cadmium orange tint 6	Orange 235,5	Sunproof orange H	Cadmium yellow orange 196
-	Cadmium red tint 6	Permanent deep red 371,5	Permanent red 3 deep B	Vermilion 80
-	Crimson lake tint 4	Carmine 318,5	Carmine red D	Helios red 682
¢	Purple tint 4	Blue violet 548,5	Bluish violet B	Blue purple 281
*	French ultramarine tint 8	Ultramarine deep 506,5	Ultramarine deep D	Sapphire blue 620 <i>or</i> Ultramarine blue 388
	Cerulean tint 4	Phthalo blue 570,5	Greenish blue B	Coeruleum 259
*	Viridian tint 6	Permanent green deep 619,5	Light green B	Viridian 250
1 and	White (cream shade)	White 100,5	White	White
ling.	Cool gray tint 4	Bluish gray 727,7	Gray blue H	Yellow gray green 497
and the second sec	Burnt sienna tint 6	Burnt sienna 411,5	Burnt sienna D	Dead leaf green 141
k,	Ivory black	Black 700,5	Black	Ivory black